The Queen Of The Night
by Dominique Collon

THE BRITISH MUSEUM PRESS

First published in 2005 by
The British Museum Press
A division of The British Museum
Company Ltd
38 Russell Square
London WC1B 3QQ

Reprinted 2007, 2009, 2013, 2016

britishmuseum.org/publishing

A catalogue record for this book is
available from the British Library

ISBN: 978-0-7141-5043-7

Designed by Esterson Associates
Typeset in Miller and
Akzidenz-Grotesque
Printed and bound in China
by C&C Offset

Map by ML Design

Acknowledgements
Dean Baylis, Laura Brockbank,
Frances Carey, Marjorie Caygill,
Annie Caubet, Matthew Cock,
Joanne Cooper, John Curtis,
Richard Falkiner, Irving Finkel,
Clem Fisher, Georg Gerster,
Daphne Hills, Neil MacGregor,
Simon Martin, Clare O'Nolan,
Ann Searight, Julia Schottlander,
Mark Timson, Charlotte Trümpler,
Susan Walby, Beatriz Waters,
Barbara Winter, Irene Winter.

Contents

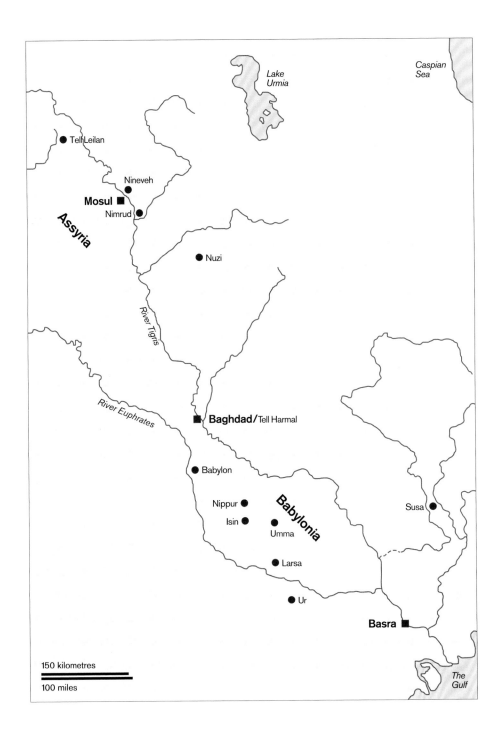

Caspian
Sea

Lake
Urmia

● Tell Leilan

Nineveh
●

Mosul ■

Nimrud ●

Assyria

● Nuzi

River Tigris

River Euphrates

■ **Baghdad/** Tell Harmal

● Babylon

Nippur ●

Isin ● ●
Umma

Babylonia

Susa ●

● Larsa

● Ur

Basra ■

150 kilometres

100 miles

The
Gulf

4

From 'Burney Relief' to 'Queen of the Night'

On 13 June 1936 the *Illustrated London News* published
a spectacular terracotta relief in the collection of Sydney
Burney. The 'Burney Relief', as it came to be known, is
a large plaque of baked clay measuring 49.5 cm high by
37 cm wide (fig. 1). Its surface is modelled in high relief
(maximum thickness 4.8 cm; see fig. 3) with the figure of
a curvaceous naked lady. She wears a horned headdress,
holds a rod-and-ring symbol in each raised hand, and has
a necklace around her neck, locks of hair falling over her
shoulders and bracelets on her wrists. Long wings hang
from her shoulders and her legs end in the talons of a bird
of prey resting on the backs of two lions; the lions recline
back to back with their heads turned towards the front.
The scene is flanked by owls, and along the base runs a scale
pattern that indicates mountainous or hilly terrain. There
are traces of red paint on the figure's body, and her wing
feathers were coloured alternately red, black and white, as
were the feathers of the owls. The background and manes
of the lions were black (fig. 2). Despite some breaks and
cracks, the plaque is in a remarkable state of preservation.

 In its 1936 publication the 'Burney Relief' had been
correctly identified as coming from ancient Iraq. Two great
rivers, the Tigris and the Euphrates, flow through Iraq,
which is often referred to as Mesopotamia, a Greek word
meaning 'the land between the two rivers'. In the north
these rivers and their tributaries, combined with sufficient
rainfall, watered the rich agricultural land. In the south
rainfall was insufficient, so fields and date-palm orchards
were irrigated by a system of artificial channels and canals
between the rivers. The rivers also provided means of access
to the raw materials that Mesopotamia lacked, from the
Persian Gulf in the south (and thence eastwards across
the Indian Ocean) to the mineral resources of Turkey in
the north, and an easy route through northern Syria to the
Mediterranean. In Mesopotamia, therefore, we find some

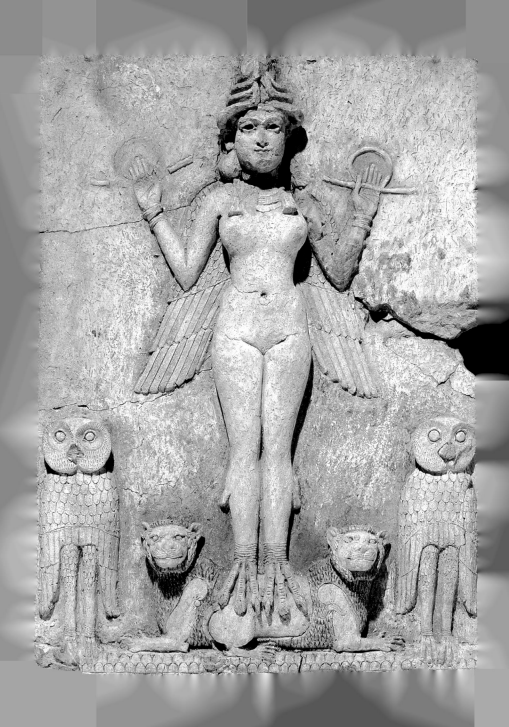

of the earliest agriculture and domestication of animals;
the organization of communities into villages and then
into cities; the development of administration, trade, an
elaborate religion, monumental architecture and the arts;
and the invention of the wheel and writing – all before
3000 BC! Mesopotamia has rightly been called the
'Cradle of Civilization'. It was in Babylonia (southern
Iraq) that the Burney Relief was made. It has become
an icon of the Old Babylonian period, the age of King
Hammurabi, who reigned from his capital at Babylon,
south of present-day Baghdad, from about 1792 to 1750 BC
(see Chapter Two; in this book the so-called 'Middle
Chronology' is used).

Little is known about how the Burney Relief came to
London. Burney had acquired it from a dealer called Selim
Homsey, the founder of a firm of the same name. The firm's
premises were at 37 St Mary Axe, London EC3. According
to a note in the National Archives (Public Record Office)
at Kew, Selim Homsey was in southern Iraq from 9 January
1924, and he could have acquired the relief on this occasion.
The Deposit Book of the Department of Egyptian and
Assyrian Antiquities at the British Museum records that on
20 February 1933 Roger Homsey, of the same firm, placed
on deposit a 'Terracotta relief (broken in 3 pieces & a
number of frags.)'. A note added in pencil refers to the later
publication of the relief by Frankfort (referred to below),
thus indicating that the fragments were indeed the Burney
Relief. The date '26/2/35' was entered in the 'Returned'
column of the Deposit Book when W. Surrey, an employee
of the Homsey firm, signed for the object. His letter of
authority, on the firm's headed writing paper, shows that at
that time the firm was directed by 'A. Homsy [*sic*.], British,
Origin Syrian', thus indicating that the family presumably
came from Homs in Syria.

During the two years that the relief was in the British
Museum it underwent scientific examination by Dr H.J.
Plenderleith, who declared it genuine in his report early in
1935. We do not know whether the relief was restored at
this time or after collection in 1935. It was, however, in its
present form when offered for sale to the Trustees of the

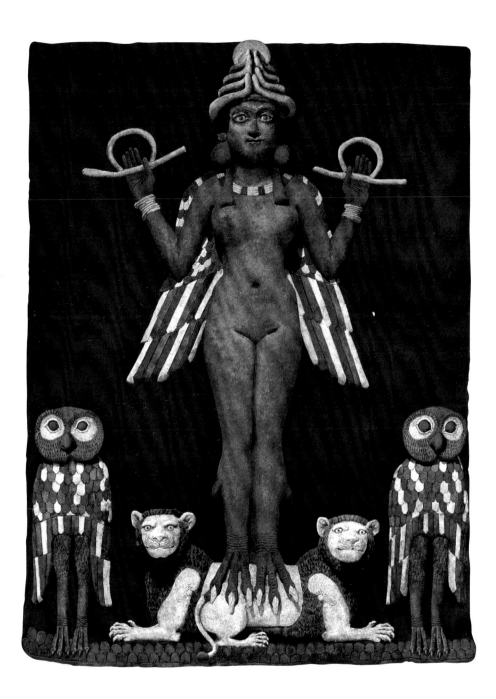

British Museum in July 1935. When the Trustees declined to purchase it, it was sold to Burney.

Because the Burney Relief was such an extraordinary piece there were, inevitably, questions as to its authenticity. Two important articles appeared in the Austrian scholarly journal *Archiv für Orientforschung*: in volume 11 (1936–7) D. Opitz challenged its authenticity, and in volume 12 (1937–9) H. Frankfort wrote what remains the best description of the relief, with convincing arguments in favour of it being genuine. In a further article in the same volume, Opitz accepted Frankfort's conclusions and withdrew his objections.

Sydney Burney is an elusive character, and has been described as 'a man of Tao who "left no tracks"'. He is not in *Who's Who* or in the *Dictionary of National Biography*. There is a brief note in the fifth volume (1951–60) of *Who was Who*: 'BURNEY, Sydney Bernard, C.B.E. [Commander of the British Empire] 1918. Served European War 1914–1918 Captain (C.B.E.); Assistant Director-General of Voluntary Organisations; subsequently became art dealer. *Address*: 26 Conduit St., W.1. Died 3 *Jan.* 1951.' Note that no date of birth is given, but according to his grandson he was seventy-four when he died. The focus of his life is dismissed in four words, yet he was President of the British Antique Dealers' Association, and set up at least one exhibition in aid of charity. In his premises (also his home) at 13 St James's Place in London, he displayed African sculpture alongside works loaned by Moore, Hepworth, Maillol and others, and ancient art together with paintings by Modigliani. Although Burney sold a number of antiquities to the British Museum over the years, he was chiefly known as a dealer in modern art.

It is strange that such a retiring figure should still be remembered due to the fact that he gave his name to a terracotta plaque from ancient Mesopotamia. However, Burney soon sold the relief to the collector Lt-Colonel Norman Colville of Launceston in Cornwall. After Colville's death in 1974 his widow put it up for auction at Sotheby's on 21 April 1975. Mr Goro Sakamoto of Kyoto, a Japanese collector and dealer, purchased it for £31,000, and painted

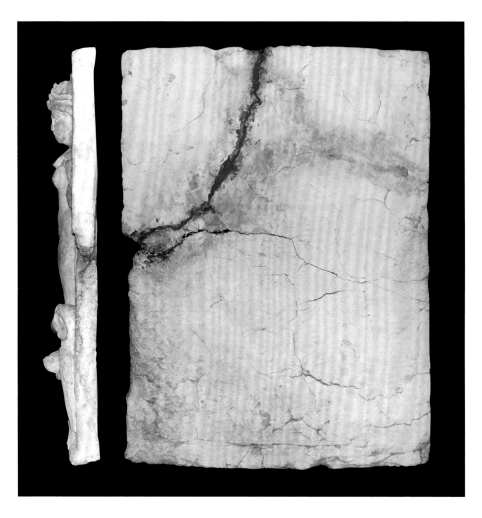

3 The reverse and one side of the relief.

his name and the year of acquisition onto the base of the plaque. However, when he wished to export the piece, the Reviewing Committee on the Export of Works of Art denied Mr Sakamoto a license because it had been in England for so long. In 1979 he tried to sell it through Christie's, but at the sale on 24 November 1979 (Lot 276) it failed to meet its reserve and was bought in at £70,000. On both occasions the British Museum attempted to acquire it. Negotiations between the British Museum and Mr Sakamoto continued over the years, with the price soaring after an Assyrian

carved panel from Nimrud in northern Iraq was sold at Christie's for £8,000,000 in 1994.

In 2002 the Museum decided to make the Burney Relief the principal acquisition for its 250th anniversary. It was finally purchased from Mr Sakamoto in June 2003 for £1,500,000, with generous grants from the Heritage Lottery Fund, the National Art Collections Fund (with a grant from the Wolfson Foundation), the Friends of the Ancient Near East, the Sir Joseph Hotung Charitable Settlement and the Seven Pillars of Wisdom Trust. It was decided to celebrate the occasion by giving the relief a new name, and so the 'Burney Relief' became the 'Queen of the Night'.

The change of name has had the unforeseen result of humanizing the plaque. Whereas the Burney Relief was always referred to as 'it', the Queen of the Night is definitely 'she'. The Burney Relief, though published many times, had only been visible to the public when loaned to the British Museum by Mr Sakamoto between 1980 and June 1991. Since her acquisition, the Queen of the Night has not only been displayed in the British Museum, but has also been on tour to Glasgow, Sunderland, Leicester, and to the Horniman Museum in south London. She has been on more extended loan to Cardiff and Birmingham. It is hoped, when the situation in Iraq is more stable, that she will be able visit her country of origin. Finally, after years in private hands, she is in the public domain.

As we do not know the figure's identity, in the following study of this remarkable ancient artefact we shall refer to it as the Queen of the Night relief, or plaque, or simply as the Queen.

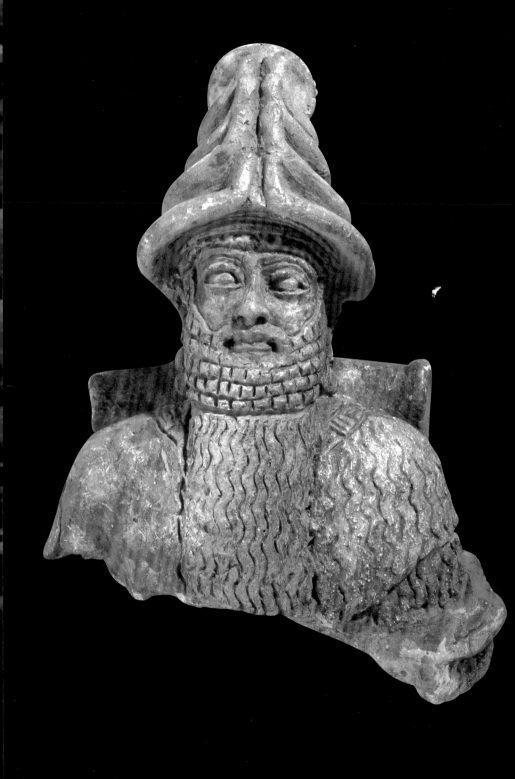

Chapter Two
Creating the Queen of the Night

4 Unbaked clay figure of a god excavated at Ur, c. 1800–1750 BC, ht 18 cm.

The making of the plaque

Examination of the plaque in the British Museum's Department of Scientific Research in 2000 showed that it was made of clay with small white calcareous inclusions which are particularly visible on the hands. Chaff was also added in order to bind the clay and prevent cracks; this was burnt out when the plaque was fired, leaving elongated voids in the clay. When the relief was made in southern Iraq shortly after 1800 BC chaff-tempered mud brick had been the main building material for about 5,000 years; whoever made the Queen of the Night relief had tremendous expertise in the material they were using.

Despite the advent of concrete, mud bricks are still made in the Near East and the method has not varied over the millennia. The clay is pressed into a mould and allowed to dry in the sun. Because baking bricks requires a considerable amount of fuel, only bricks for very important buildings are baked. Examination of the breaks in the relief shows that the figure was made from fairly stiff clay which was folded and pushed into a specially shaped mould, with more clay added and pressed in behind to form the plaque. Thus the Queen's figure is an integral part of the plaque and was not added to it later. After drying, the plaque was removed from the mould, the details were carved into the leather-hard clay and the surface was smoothed. This smoothed surface is still visible in certain places, notably near the Queen's navel. In some cases extra pieces of clay were added. This is clearly the case with the symbolic objects held by the Queen: the craftsman rolled some clay between the palms of his hands into a long, thin piece. He then attached (luted) it to the plaque, using a fluid clay slurry as a cement and keying it in position with little incisions into the plaque's surface. These telltale marks are clearly visible where the symbol on the left is partly missing (see figs 1 and 11). The edges of the plaque were trimmed with a knife. Then the plaque was baked.

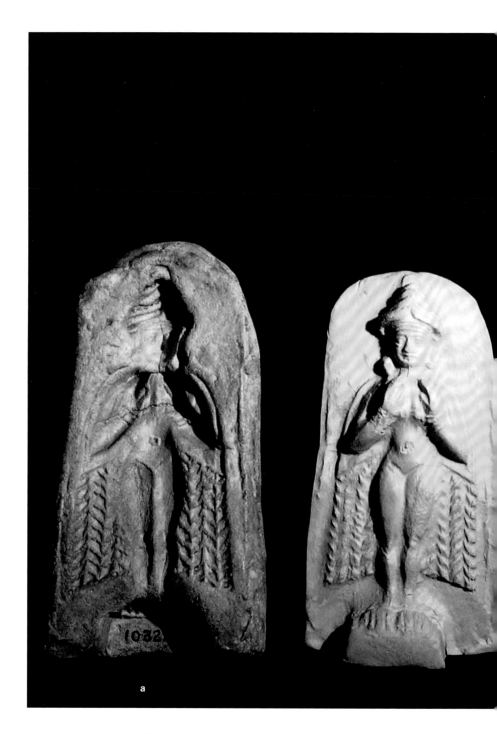

a

14

5 a) Ancient clay mould and modern impression made from it, c. 1850–1750 BC, ht 12.5 cm; b) Terracotta plaque, ht 17.6 cm.

b

a

b

c

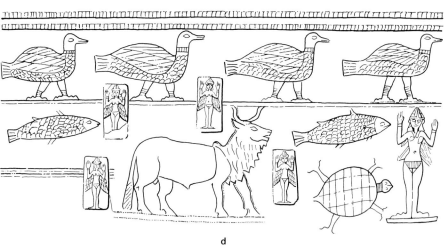

d

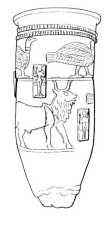

e

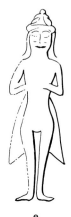

f

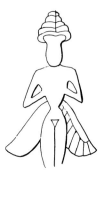

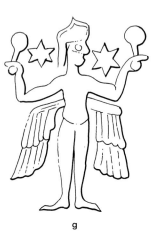

g

The plaque was in three main pieces and several fragments when it was taken on deposit in the British Museum in 1933. The examination carried out in 2000 and a subsequent X-ray (obtained with the permission of Mr Sakamoto) demonstrated the extent of these breaks. As is clearly visible on the reverse (fig. 3), some of the cracks were far more carefully repaired that others.

There are still substantial remains of paint on the plaque. Red ochre was used to paint the body of the Queen and some of the beads of her necklace. Although originally Plenderleith had thought that bitumen was used for the background, more recent analysis has shown that charcoal and soot were used not only for the background, but also for the Queen's hair and eyebrows, for the manes of the lions and for the scale pattern at the bottom of the relief. A gypsum pigment was used for the white bodies of the lions. All three colours were used for the figure's wings and for the owls. The digital reconstruction produced by the British Museum's New Media Unit (see fig. 2) shows how startling the result must have been, with the Queen of the Night and her attendants emerging from the dark background. Apart from a few of the smallest feathers of the owls and their beaks (both broken), the evidence for the original colours can still be detected. The Queen's eye sockets were hollowed out and had presumably been inlaid (see Chapter Three). However, no traces of pigment survive for her horned headdress, the horizontal beads of her necklace, her bracelets and the symbols she holds. In the reconstruction they have been coloured yellow on the basis of the description of a clay figure of a god (fig. 4) made at the time of its discovery.

Only the upper part of this god survives. It was excavated at Ur in southern Iraq by Sir Leonard Woolley in 1930–31 and is now on display in the British Museum alongside the Queen of the Night. There are many similarities between the god and the Queen, which are contemporary. Both are made of clay to the same high standard, but the god is modelled in the round and the clay is unbaked; both are painted in the same range of colours: black, white, and the same rich red for the skin. Yellow was used for the god's

horned headdress (presumably to indicate gold) and for his necklace, with alternating groups of vertical red beads and horizontal yellow beads. The goddess's headdress and necklace are identical. Unfortunately, although the god's headdress and beads still have a yellow tinge, it was impossible to find a sample of pigment for analysis, although presumably yellow ochre was used.

Dating the plaque

Mould-made plaques showing a winged naked female goddess with bird talons (figs 5a–b and 6a–d), known from Babylonia in southern Iraq and dated to between 1900 and 1700 BC, indicate the rough location and date of manufacture of the Queen of the Night relief. However, on stylistic grounds the date can be narrowed still further. In 1894 BC a Semitic-speaking Amorite ruler founded a new dynasty in Babylon, a small town on the Euphrates. Gradually the First Dynasty of Babylon grew in importance. A century later, under a dynamic ruler named Hammurabi (1792–1750 BC), Babylon gained control of present-day Iraq and parts of Syria.

A major work of art surviving from the time of Hammurabi is the famous black diorite stele known as the Code of Hammurabi (fig. 7), measuring 2.25 m high and inscribed with a law code in 3,500 lines of cuneiform. At the top a relief 65 cm high shows Hammurabi standing before the seated sun god Shamash. The god's headdress is the same as that worn by the Queen and the god from Ur. Though considerably smaller, the Queen of the Night equals the Code of Hammurabi in quality of execution, and surpasses it in iconographical originality. Both have long been considered to be the major surviving works of art of the age of Hammurabi. A date in Hammurabi's reign is further supported by the Thermoluminescence test carried out in 1975. This test dates the firing of a clay object, but produces such a wide date range that it is most useful for indicating whether an object was fired in antiquity, or more recently, and therefore whether it is genuine or not. In the case of the Queen, it indicates a date between 1765 and 45 BC – the former date falling within the reign of Hammurabi.

Where in Babylonia was the plaque made?

We will probably never know where the plaque was made. The remains of Hammurabi's capital now lie inaccessible beneath the high water table and the cities built by his successors, including Nebuchadnezzar II (604–562 BC). Babylon is very close to the River Euphrates, which has shifted its course throughout history and at the time of Nebuchadnezzar ran right through the middle of the city. On fig. 8 the river can clearly be seen flowing diagonally across the top left-hand corner of the photograph. A square in the foreground represents the outline of the ziggurat, or temple tower, of Babylon – the origin of the biblical 'Tower of Babel' (Genesis 11:1–9). As the ziggurat was a very

7 Detail of the upper part of the Code of Hammurabi stele, c. 1760 BC; ht of stele 2.25 m; ht of relief 65 cm.

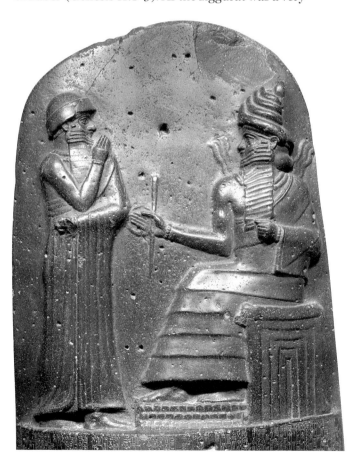

important building it was faced with long-lasting baked
bricks over a mud-brick core. The stairway giving access
to the upper stages (the perpendicular line at the bottom
of the square), was also built of baked brick. These bricks
were removed in the nineteenth century and re-used in
the building of the nearby modern town of Hilla, leaving
the eroded mud-brick core surrounded by robber trenches
that are now ditches filled with water and reeds – a clear
indication of the height of the water-table.

The ruins lying across the top of the photograph were
excavated by German archaeologists from 1896 onwards.
They include the foundations of the processional way and
Ishtar Gate (partly reconstructed in the Vorderasiatische
Museum in Berlin), and Nebuchadnezzar's palace, rebuilt
by the Iraq Directorate of Antiquities on the foundations
excavated by the Germans, and incorporating bricks
bearing the stamp of Saddam Hussein. Hammurabi's
levels were not reached, and there are almost no objects
from the site dating to his period. The Code of Hammurabi
survived because it had been carried off as booty to Susa in
south-western Iran in about 1157 BC, and was found there
by French archaeologists in 1902; it is now in the Louvre
in Paris. The German excavators did, however, find in
1910 the upper part of a terracotta water god 7.5 cm high,
wearing a headdress with a round top and a single pair
of horns, and bearing traces of red paint on his body (also
now in Berlin). Although clearly closely contemporary
with the Queen, stylistically it is rather different.

The god from Ur (see fig. 4) is, however, so close to
the Queen of the Night in quality, workmanship and
iconographical details that it could well have come from the
same workshop, perhaps at Ur, where extensive remains of
the Old Babylonian period were excavated between 1922
and 1934. Recently another clay figure was found near Ur
(now in the Iraq Museum in Baghdad), which depicts a
water god in the round, wearing a headdress similar to that
worn by the Queen, but otherwise in a completely different
style from the Queen, Ur and Babylon examples.

There are numerous other Babylonian cities which
could claim to be the original home of the Queen. In 1980

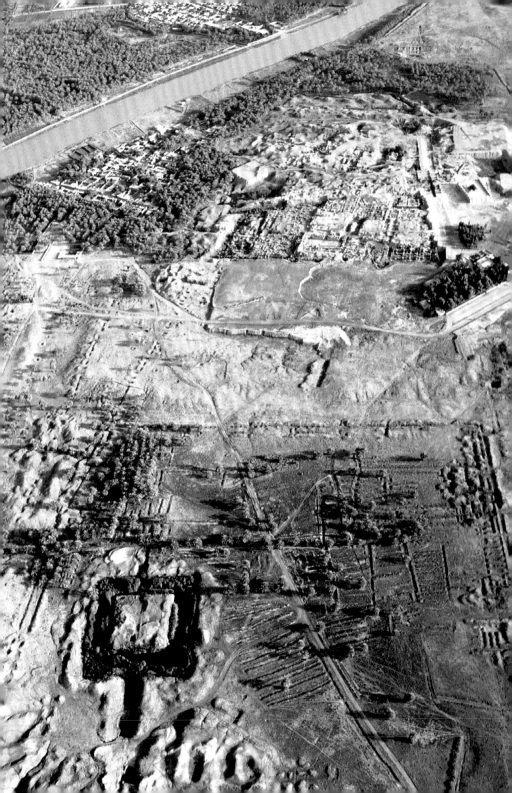

Edith Porada suggested Nippur because of the large number of clay plaques found there, including some depicting similar lions (fig. 9); other small plaques showing goddesses with wings and bird talons have also been found at Nippur (see fig. 6a). A vessel from Larsa (see fig. 6d) is decorated with minute plaques depicting the same goddess, also with both hands raised like the Queen, alongside a larger incised and painted version. At Isin a fragment of a small terracotta figure, carefully excavated by German archaeologists, shows a necklace similar to that worn by the Ur god and by the Queen; sadly the site was completely ransacked by looters in the aftermath of the Second Gulf War. Another city may equally well have specialized in the production of three-dimensional figures and large-scale plaques carved in high relief. There is also the possibility that itinerant craftsmen travelled with their moulds from city to city, using the local clays.

The purpose of the plaque

As we shall see the Queen of the Night was certainly a goddess and the plaque was probably set up in a shrine. Thorkild Jacobsen (see Chapter Four, *Ishtar*) suggested that the shrine could have been in a brothel, but if this were so, it must have been a very high-class establishment, as demonstrated by the exceptional quality of the piece. The plaque would have been set into an interior mud-brick wall of the shrine. When the building was abandoned, the wall would eventually have crumbled and the plaque fallen to the ground and broken. The heads of the lions and the front of the Queen were not badly damaged and the relief must have been protected from the elements. Meanwhile, the remains of the mud-brick wall would have been eroded by the wind and rain, whilst the baked plaque survived until eventually found by someone wandering over the site.

However, another scenario is possible: the main break may have been caused by a blow that struck the relief below and slightly to the right of the Queen's adjacent elbow, leaving a deep, elongated hollow at the top of the 'V' formed by the missing piece. Someone may have aimed a

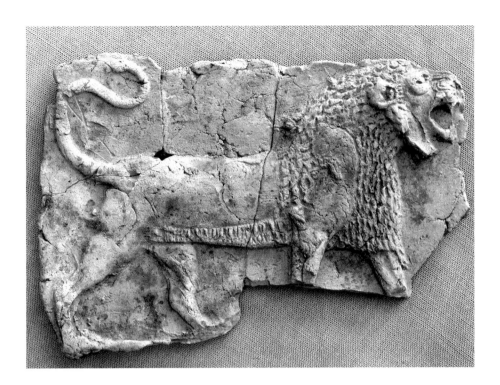

9 Terracotta plaque
excavated at Nippur
in southern Iraq,
c. 1850–1750 BC,
ht 8.1 cm.

blow at the relief at some period of insecurity, perhaps when the Hittites from central Turkey carried out a lightning raid into Babylonia in 1595 BC, and brought about the collapse of the First Dynasty of Babylon.

Chapter Three
The Queen of the Night and her attendants

10 The upper part of
the Queen of the Night,
seen from the side.

In this chapter the various features of the relief will be examined in turn.

The Queen

The Queen is depicted strictly frontally and symmetrically, looking straight ahead (see figs 1–2). In art, frontality indicates communication with the viewer, and this is particularly evident later, in Byzantine art. In Mesopotamian art there was a tendency to avoid frontality, probably for strictly practical reasons (see below). The main vehicle for Mesopotamian art was sculpture in low relief, from the miniature scenes depicted for about 3,000 years on cylinder seals to the often over life-size figures on Assyrian wall reliefs of the first half of the first millennium BC.

Cylinder seals (see figs 6e–g and 18) were a particularly Mesopotamian sealing device used from about 3400 BC for some 3,000 years for marking ownership, protecting property and later, particularly in the Old Babylonian period, for sealing letters and contracts written on clay. Under Mesopotamian influence their use spread to neighbouring countries. They are, as the name implies, cylinders on average about 2.5 cm high and 1.5 cm in diameter, perforated vertically so that they could be worn on a pin or cord. They were generally made of stone, carved in intaglio with a design that would appear in relief when the seal was rolled out on clay. Over the millennia, the designs changed, and provide insights into contemporary religion and myths, dress, daily life and so on. At some periods inscriptions accompany the designs, typically giving the name and profession of the owner, and the name of the deity, or more rarely king, he or she served. Cylinder seals were also used as amulets and items of jewellery. On these miniature reliefs, as on their larger counterparts, the head and legs are shown in profile and the torso is shown frontally. In low relief it is difficult to depict a face

convincingly without the features – particularly the nose – appearing as flattened. As the Queen is carved in high relief the problem does not arise. Nevertheless, certain figures are consistently shown frontally in Mesopotamian art: the goddess Ishtar, the human-headed bull, the bull-man, the nude bearded hero and the demon Humbaba who guarded the cedar forests. Apart from Ishtar, who will be discussed in Chapter Four, the others are generally beneficent protective figures, and frontality is probably used to allow the viewer to catch their attention and communicate with them. Ishtar's frontal depiction may perhaps be based on a famous cult statue.

The Queen's face is oval. Her eye sockets were hollowed out to receive inlay, probably of white shell into which a small disc of lapis lazuli would have been inset for the iris. The eyes of many important contemporary and earlier Mesopotamian statues, going back to before 3000 BC, were inlaid in this way. Lapis lazuli, a brilliant blue stone, was imported from Afghanistan and was therefore highly prized. The eyelids would have been black, representing khol (mascara) as used by Ishtar (see Chapter Four). Double incised arcs, meeting above the nose, mark the black eyebrows. This feature appears on many Mesopotamian sculptures and must have been a common physical characteristic that is still occasionally found in Iraq. The ear on the left is carefully depicted as if seen from the side, but the ear and bunch of hair on the right are missing due to the break. The nose is slightly chipped on the right. The bow-shaped mouth is closed, with the corners curving up very slightly.

The Queen's face and body were painted overall in red ochre paint, substantial traces of which survive, especially on her hands, where there is a concentration of calcareous inclusions in the clay, and on her left elbow, near the break, due to soil and salt encrustation. The red paint is also clearly visible on her neck, in the creases of her right elbow, around her navel, between her legs, around her 'dewclaws' and on her talons. Her nipples look darker red, possibly because the paint was thicker or darker there. Her pubic triangle is also slightly darker, but examination under

11 *Overleaf* Detail
showing the upper part
of the Queen.

ultraviolet light showed that this might be due to
restoration work. This red colour is very striking, and also
appears on other contemporary sculptures of both men and
women, including the god from Ur (see fig. 4). This is in
contrast to the custom in Egypt where men were painted
red whilst women were shown with much lighter skin.

The Queen looks benign, but aloof. Depending on the
lighting, she can seem faintly amused. However, she never
leaves us in any doubt that she is a queen and not to be
trifled with!

Headdress

The Queen wears a headdress, partly damaged on the right,
consisting of four superimposed pairs of bull's horns
surmounted by a disc (see figs 10 and 11). The horned
headdress was closely associated with gods and goddesses
from about 2500 BC, and occasionally with deified kings.
The number of horns could vary and does not seem to have
denoted rank. The four-horned variety topped by a disc
first appears around 2100 BC and seems to have been
particularly popular during the reign of Hammurabi
(see fig. 7). The figure of the god (see fig. 4) shows that
the band above the Queen's forehead could be either part
of her headdress, in which case it would have been yellow,
or – as reconstructed in fig. 2 – part of her hair, and
therefore black.

Hairstyle

The Queen's black hair is arranged in large bunches on her
shoulders; two 'wedges' hang downwards above her breasts.
Three-dimensional figurines and sculptures make it clear
that these wedge-shapes are indeed hair, but it is possible
that the stylization indicates a ceremonial wig such as that
worn by Ishtar (see Chapter Four).

Necklace and bracelets

The Queen wears a necklace consisting of groups of
horizontal and vertical beads. The colour of these has been
restored on fig. 2 on the basis of the identical necklace worn
by the figure of the god from Ur (see fig. 4) where traces

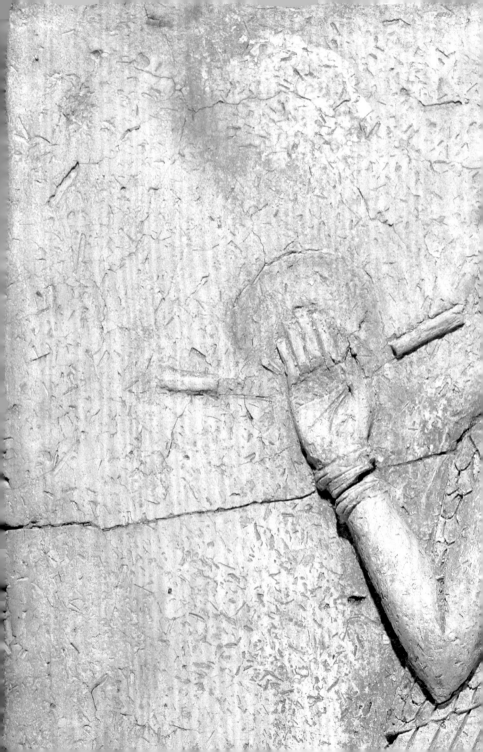

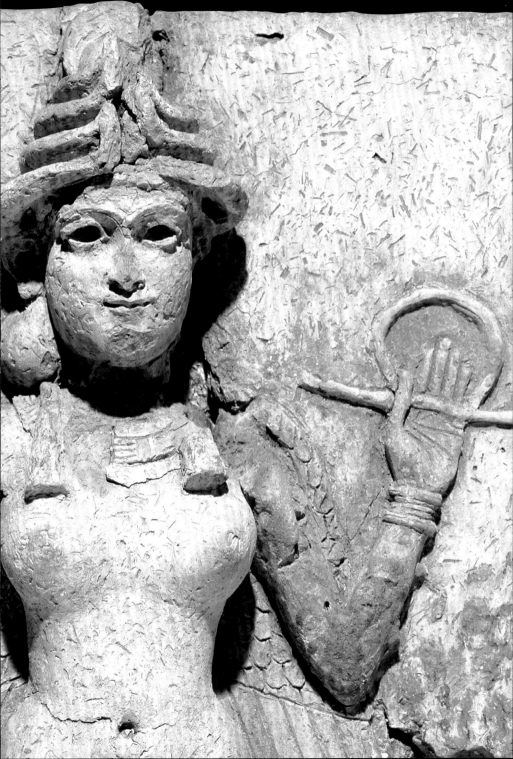

of paint survive: yellow (presumably for gold) and red (probably indicating carnelian beads). It has been suggested that at least some of the beads could have been painted blue (for lapis lazuli) to match the description of Ishtar's necklace in Chapter Four, but there is a faint tinge of red on some of the vertical beads and, in any case, blue pigment does not seem to have been part of the Old Babylonian palette, at least in southern Mesopotamia. It is intriguing to speculate how such a necklace may have been strung. We know from three-dimensional statues and figurines, and depictions on cylinder seals, that necklace counterweights often had to be worn hanging down the back, indicating that necklaces could be very heavy. Bracelets are relatively rarely shown on sculptures and seals, but the Queen has a substantial bracelet on each wrist. They consist of a thick grooved ring top and bottom, with three grooves between them.

Hands
The Queen holds symbols in each hand between her thumb and palm (fig. 11). The hands are open, with the extended fingers together, the palms towards the viewer, and the thumbnail visible in profile. We do not know to what extent palmistry was then practised, if at all, but what are now known as the heart, head and life lines are clearly identifiable.

Rod-and-ring symbols
The rod-and-ring symbol is thought to have derived from a measuring rod and tape used for surveying land. It became a symbol of divinity, and was the particular attribute of the sun god Shamash who, because he saw everything, was also the god of justice. On Hammurabi's Law Code (see fig. 7), Shamash extends the rod-and-ring towards King Hammurabi as a symbol of justice and kingship. In Chapter Four, Ishtar is described as holding a rod-and-ring of lapis lazuli. It has been suggested that the symbols held by the Queen might, therefore, have been painted blue, but, as stated above in connection with the necklace, blue pigment does not seem to have been part of the Old Babylonian palette. Uniquely, the Queen holds two of these symbols

– one in each hand (fig. 11). From the purely aesthetic point of view, this was probably dictated by the strict symmetry of the composition. It is also possible that deities are not normally shown holding two rod-and-ring symbols because they are generally depicted in profile and hold another attribute as well – a scimitar in the case of Ishtar. The Queen's entitlement to these symbols will be discussed further in Chapter Four.

Wings

The Queen's wings were attached to her shoulders, above which a rim of feathers can be seen, and they hang down on either side. The feathers were painted alternately black, red and white. On the right they form a regular zigzag pattern, but on the left the presence of an extra feather in the bottom row upsets the patterning. Wings are often associated with the goddess Ishtar in her aspect as the goddess of the morning and evening star, but her wings never hang down (see fig. 18). Edith Porada demonstrated that drooping wings are connected with demons and the Underworld, but here demons can be ruled out as the Queen wears the headdress of a goddess. The drooping wings on the small clay plaques with the Queen motif are all attached to the shoulders (see figs 5a–b and 6a–d).

A few cylinder seals also seem to show a goddess resembling the Queen, but the feet are not clear and the wings are attached at the waist. Two date to the Old Babylonian period (see fig. 6e from Tell Harmal in present-day Baghdad, and fig. 6f on an ancient impression, possibly made by a seal from Babylonia but found at Tell Leilan in Syria). A third example (see fig. 6g) is an impression of the fourteenth century BC from Nuzi in central Iraq. It is interesting because the two objects the goddess holds are probably mirrors, though they could perhaps ultimately have been derived from rod-and-ring symbols.

'Dewclaws'

Halfway down the outer side of each of the Queen's calves is a fleshy excrescence, which goes almost unnoticed (fig. 12). I thought at first that these were spurs, such as those of

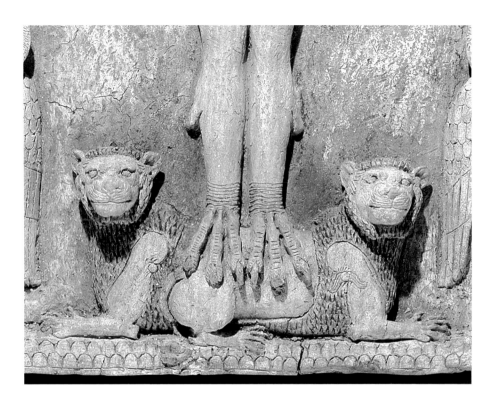

fighting cocks; however, domestic fowl are of Indian origin and were unknown in Egypt and the Near East until around 1250 BC. Owls do have a fourth talon (see below), but this is at the bottom of the leg. If the creator of the plaque had wanted to show another talon, he would certainly not have depicted it in this way! The closest parallel is a dog's dewclaw – a non-functional fleshy excrescence at the back and further up the front legs.

Why would the Queen have dewclaws? Dogs were associated with Gula, the Mesopotamian goddess of healing, but this would seem a rather obscure allusion to her. A further clue may lie in a small, mould-made clay plaque in the Louvre in Paris (see fig. 6c), which shows a similar goddess with lowered wings and bird talons; whereas the Queen stands on lions, however, this goddess stands on the backs of two wild goats. She also has excrescences emerging from the sides of her legs, but here they are split and

resemble rudimentary hooves – a feature of goats, deer and some other ungulates, and which is also called a dewclaw. If a goddess standing on goats has the dewclaws of a goat, perhaps the Queen's dewclaws are related to her lions. Although lions do not have dewclaws, they do have a 'carpal pad' in the same position. Some artistic licence may have led to the emphasis of the carpal pad in order to reinforce the connection between the Queen and her lions.

Talons
Where the Queen should have feet, she has frighteningly huge talons (fig. 12). Around her ankles there are grooves: seven on the left ankle and nine on the right. From each of these rather innocent 'ankle socks' three red talons emerge, knobbed, ridged and ending in enormous curved and pointed, white-painted nails. The Queen looks so 'normal' that they are shocking. On closer inspection they turn out to be larger versions of the owls' talons, and will be examined in connection with those birds.

Lions
The Queen's lions are small and lie in opposite directions, with the lion on the right overlapping that on the left (fig. 12). Their heads are turned outwards to face the viewer and their jaws are firmly closed. Their claws are not retracted, but clearly visible. Their black manes were slightly lighter than the black background against which they lie. In contrast, the heads and bodies of the lions were painted white. The mane on the top the heads is short, almost a crew-cut, leaving the round ears clearly visible. The mane above the shoulders is also short and cut flat like a raised box, perhaps indicating the powerful underlying muscles. The shoulders are bare, revealing a strange incised feature that will be discussed below. The mane is thick on the chest and extends beneath the belly. Only the tail of the lion closest to the viewer is visible: it has two ends, both of which were painted black: one hangs down over the scale pattern at the bottom of the plaque, whereas the other curls up and ends beneath one of the Queen's nails. Lions were often shown with tails curling

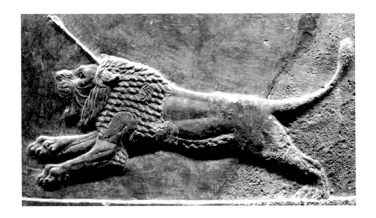

up over the haunches, so here the craftsman seems to have become confused.

When the British archaeologist Austen Henry Layard was in Mesopotamia in the mid-nineteenth century, he recorded that there were lions without manes in the south of Iraq, and lions with black manes in south-western Iran. In nature, however, varieties of male lions both with and without manes can occur together, and the colouring of the mane can vary considerably within the same area. The lions Layard saw belonged to the *Panthera leo persica* or Asiatic family of lions, which once ranged from Greece to India. All are now extinct apart from those in the Gir National Park in Gujarat. In Iraq and Iran the last lions were recorded in the early 1940s.

The Asiatic lion tends to be smaller than the African, with a shorter mane, allowing the ears and often the shoulders to be visible, with a distinctive belly-fold, and a longer tuft to the tail. However, all these features can occur in the African lion (the two can interbreed); the only truly distinguishing mark is the presence of two foramens (holes in the skull) for the Asiatic lion, as opposed to the single foramen of the African lion – only visible when a lion is dead. The DNA of African and Asiatic lions is also different.

Both lions and lionesses with and without manes are represented in the art of the ancient Near East. Some have a distinctive whorl on the shoulder (fig. 13) and this is clearly apparent on the only skin of a Persian lion in the Natural History Museum in London (ZD.1847.12.5.1). It is

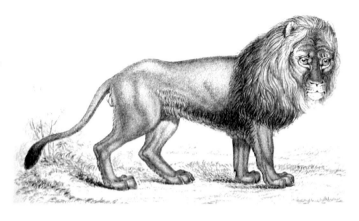

also distinctive of Gir lions from India. The earliest depictions of this feature date to the Old Babylonian period in a form resembling a drooping bow or moustache: on the Queen's lions (emerging from a whorl), on lions depicted on small, mould-made plaques from Nippur in southern Iraq (see fig. 9), and on the fragment of a large terracotta lion in the Burrell Collection in Glasgow.

Another distinctive feature is the band of fur along the belly of the Queen's lions. This is also depicted on the lion in fig. 9 and was visible on an actual lion from Basra, in southern Iraq, which was presented to George IV. It was on display in the Surrey Gardens Zoo in 1833, where Edward Lear (of *Nonsense Rhymes* fame) painted it; an engraving of it was published the next year (fig. 14).

The Asiatic lion is generally described as having had a light, tawny coat, and perhaps this is why the Queen's lions were shown as white, to contrast with the black mane. However, if there is a connection with the Underworld, as suggested by the Queen's lowered wings, then perhaps these are anaemic Underworld lions (see Chapter Four, *Ereshkigal*).

Normally lions are depicted roaring (see fig. 13), but these small lions have their mouths firmly closed. They look outwards, proud, on guard, alert and apparently fully in control. Their attitude is similar to that of the large reclining lions that flank the North Entrance of the British Museum.

Owls

Two owls, depicted frontally on either side of Queen, are also mounting guard, and they dwarf the lions (fig. 15). The most common owls in Iraq are the Little Owl, the Tawny Owl and the Barn Owl, all virtually indistinguishable from their European counterparts. Other owls have ears, which the Queen's owls lack. The Little Owl, well known in later Greek art and coinage through its association with Athena, is also sometimes called the Lilith Owl, and this will be discussed further in the next chapter. The Barn Owl (fig. 16), unlike the Little and Tawny owls, stands upright, like the owls that flank the Queen. Her owls also have discs around the eyes characteristic of Barn Owls. However, from the visible remains of paint, the artist seems to have taken some liberties with their colouring, although the eyes did stand out against a white background. The legs of a Barn Owl are covered with white feathers and down, but the legs of the Queen's owls were red, the feathers only appear on the upper part, and there are bands above the talons: six on each leg for the owl on the left, and five on each leg for that on the right. Indeed the lower parts of the legs of the owls are miniature versions of the Queen's legs. Three talons are shown: in nature owls tend to have two claws at the front and two at the back, but one of the back claws is double-jointed and can be flicked forward, as is the case with the Queen's owls and with the Barn Owl in fig. 16.

The scale pattern

There are two rows of scale pattern running along the bottom of the plaque, with a line below them. The lions recline on them and the owls stand on them. This pattern was used in Mesopotamia to represent mountains and hills from before 3000 BC right through into the first millennium BC, when Assyrians used the convention to denote campaigns in hilly and mountainous terrain on the stone relief panels that decorated their palaces. Many of these reliefs are on display in the British Museum.

15 *Above* Details
showing the Queen
of the Night's owls.

16 *Right* Illustration of
a Barn Owl by Jemima
Blackburn (1823–1909);
graphite with
watercolour,
31.1 x 14.1 cm.

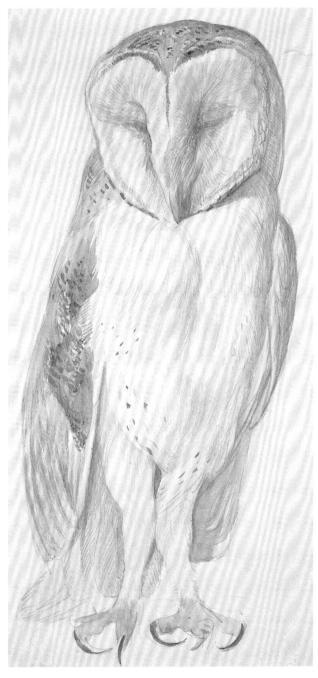

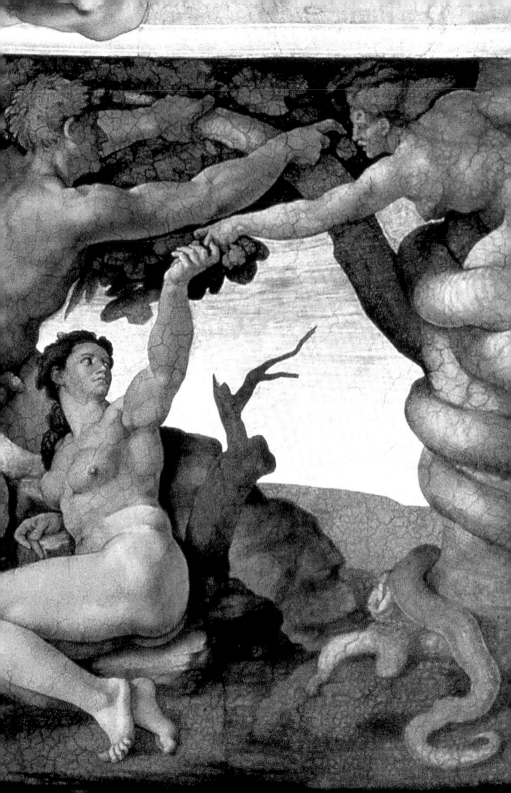

Who was the Queen of the Night?

Ever since the plaque was first published in 1936 there has been much debate about the Queen's identity. Here we shall examine three suggestions and review them in the light of the detailed study of the relief in Chapter Three.

Lilith

Lilith is the Hebrew name for a demoness who appears once in the Bible, in some translations of Isaiah 34:14 (others substitute 'screech owl'). The context is a prophesy against Edom which will become a wasteland inhabited by hyenas, owls, vultures and Lilith (Lamia in Greek). In the Jewish Talmud Lilith has long hair and wings, and attacks men, causing impotence. According to legend she was Adam's first wife but she flew away after a quarrel relating to sex, and has since been a danger to children. In medieval times she was associated with the temptation of Adam and Eve: Lilith appears in a wonderful fresco of the Fall of Man by Michelangelo (1475–1564) (fig. 17). She is depicted as a naked woman, with her serpentine legs – ending in a snake's tail – wound round the trunk of the Tree of Knowledge. She leans out of the branches to hand an apple to Eve while Adam stretches his hand towards her. On the right Adam and Eve are driven out of the Garden of Eden by an angel.

These are late non-Mesopotamian sources, but the name Lilith is connected to that of the Mesopotamian demoness Lilitu, always referred to in texts as one of a triad of demons. Lilu is male, haunts open country and is especially dangerous to pregnant women and infants. Lilitu seems to have been Lilu's female counterpart. Ardat-lili ('maiden Lilu') frequently appears in texts: 'She is not a wife, a mother; she has not known happiness, has not undressed in front of her husband, has no milk in her breasts', and was believed to cause impotence in men and sterility in women; as such she seems to have been closer in character to Lilith.

However, there are no known Old Babylonian attestations of this triad of demons.

Due to confusion with Ardat-lili, Lilitu is also said to appear in a Sumerian myth entitled *Inanna and the Huluppu Tree*. Inanna (the Sumerian name for Ishtar – see below) plants the *huluppu* tree in her city of Uruk, planning eventually to make a throne and a bed from its wood. However, a serpent nests in the roots, the Anzu-bird sets its young in the tree's branches, and the 'dark maiden Ki.sikil.lil.la' (= Ardat-lili) makes her home in its trunk, and they all refuse to be dislodged. In the end, with the help of the faithful Ninshubura (see also below), Inanna/Ishtar does get her throne and bed.

Apart from the fact that the name is not attested as early as the Old Babylonian period, there is a major drawback to any identification of the Queen with Lilitu/Lilith: the cuneiform sign DINGIR (god/goddess) *never* precedes the name Lilitu, or the names of the other members of her triad. Lilitu was a demoness and *not* a goddess, whereas the Queen's headdress and the rod-and-ring symbols she holds unambiguously indicate her status as a goddess. The only link between the Queen and Lilith is the connection of both with owls, and the fact that an alternative (modern) name for the Little Owl is 'Lilith Owl'. The owls that flank the Queen are, however, Barn Owls!

Ishtar

The Mesopotamian goddess of sexual love and war was known as Inanna in Sumerian and as Ishtar in Akkadian; these were the two languages of Babylonia until about 2000 BC when Semitic Akkadian became the dominant language. Ishtar was also associated with the planet Venus – the morning and evening star – and is therefore sometimes depicted with wings rising from her shoulders (fig. 18). As a goddess of war she generally wears an open robe allowing her freedom of movement, has weapons rising from her shoulders, and always grasps a scimitar-sword in her lowered left hand; in her right hand she holds either the double-lion-headed mace, or the rod-and-ring symbol, or the leash of her roaring lion on whose back she

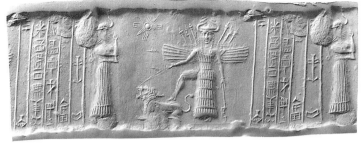

rests one foot. In the third and early second millennium she is almost always depicted full-face, often with a necklace (sometimes wrongly described as a beard!) and with two locks of hair hanging above her breasts (compare figs 2 and 18). She had cult centres all over Mesopotamia and hundreds of minor shrines.

In an article published in 1987 the Danish scholar Thorkild Jacobsen suggested that the Queen is an aspect of the goddess Inanna as goddess of harlots, and that the plaque was set up in a brothel. He gave a number of reasons for this:

1. Lions are an attribute of Inanna.
2. The mountains beneath the lions are a reflection of the fact that Inanna's original home was on the mountaintops to the east of Mesopotamia.
3. Inanna took the rod-and-ring with her in her descent to the Underworld, and her necklace identified her as a harlot.
4. Her wings, bird talons and owls 'show that Inanna is pictured in her aspect of Owl goddess and goddess harlots, Ninnina, in Akkadian Kilili'.

Inanna's Descent to the Underworld, to which Jacobsen refers, provides a description of Iananna/Ishtar that is relevant here. Inanna had set her heart on a visit to the Underworld, using as an excuse her wish to attend the funeral rites (and particularly the wake!) of her brother-in-law Gugal-ana, the first husband of her sister, Ereshkigal,

Queen of the Underworld. She put on her most alluring and powerful items of finery: a turban for the open country, wig, lapis-lazuli necklace, lapis-lazuli amulets and a pectoral called 'Come, man, come' on her breasts. She wore a 'garment of ladyship', kohl on her eyes called 'Let a man come, let him come', and golden bracelets on her wrists; in her hand she held a lapis-lazuli rod-and-ring symbol. This attire was not very suitable for a funeral and, on Ereshkigal's instructions, she was stripped of each item one at a time, according to 'the sacred customs of the Underworld', as she passed through the seven gates of the Underworld. By the time she reached her sister, Inanna was completely naked, but insisted on sitting on Ereshkigal's throne. Judgement was passed on Inanna and she was turned into a piece of rotting meat hung on a hook.

Luckily Inanna was saved by her assistant, Ninshubura, but was obliged to provide a substitute in the Underworld. Since her husband, the shepherd Dumuzi, was enjoying life without her, she chose him as substitute for six months a year; for the other six months his sister, Geshtinanna, took over. This theme of a dying god was to recur repeatedly in the mythology of many cultures.

Let us examine Jacobsen's points. As regards the first, Ishtar is associated with one lion, not two, although there is a possible exception. A few Old Babylonian cylinder seals depict a frontal, robed goddess standing on the backs of two lions. She holds a double lion-headed mace, the attribute not only of Ishtar, but of other warrior deities. If this goddess is Ishtar, she represents yet another aspect of the goddess. There is also a connection with the Underworld as on one of these seals she appears alongside the winged goddess illustrated on fig. 6f, but much larger.

With regard to the third and fourth points, Inanna/Ishtar's wig, kohl, necklace, bracelets and rod-and-ring in the myth are all probably worn or held by the Queen, but could have been worn or held by any goddess; the headdress seems to have been of a different type, and the amulets, lapis lazuli and robe are missing on the plaque. Furthermore, it seems that the association of Ishtar with prostitution is not attested in the Old Babylonian period,

but appeared at a later date. The owls, though perhaps an aspect of Inanna in texts, are not known as an attribute of Ishtar; indeed the caption to the first published photograph of the Queen of the Night relief in 1936 read: 'Ishtar ... the Sumerian goddess of love, whose supporting owls present a problem'. In some translations of the myth discussed above in connection with Lilith, the bird that perches in Inanna's tree is called an owl; however, it is the Anzu-bird, generally depicted as a lion-headed eagle or lion-dragon. As we shall see, with the exception of the first, three of the points listed by Jacobsen could also be used to prove that the goddess is Ereshkigal.

Certain Mesopotamian deities, Ishtar among them, have a well-established iconography. The lion and weapons remain her attributes from around 2250 until about 550 BC. If the Queen is Ishtar, it is surprising that there is not some iconographical clue to her identity, but the weapon attributes normally associated with Ishtar are absent both on the Queen of the Night relief, and on the small terracotta plaques and seals which show a similar figure (figs 5a–b and 6a–g); the latter also omit the lion.

Ereshkigal
According to the myth *Inanna and the Huluppu Tree*, referred to above in connection with Lilith, Ereshkigal, the 'Queen of the Great Below', was given the Underworld as her domain at the beginning of time. She was Inanna/ Ishtar's elder sister but, as we have seen, there was no love lost between them. In ancient Mesopotamia, the Underworld was a place where all the dead were gathered. It was below the earth, accessible by a stairway down to the gate of Ereshkigal's palace, Ganzir. Possibly because of confusion between the two meanings of the Sumerian word KUR – 'earth, ground, Underworld' and 'mountain, mountains, foreign land' – it also seems to have been located in the eastern mountains, depicted as a scale pattern at the bottom of the Queen of the Night relief. According to an inscription of about 2250 BC, Lu-Utu, governor of Umma, dedicated to Ereshkigal, 'the Lady of the place of sunset ... a temple in the place of sunrise, the

place where fates are determined' (fig. 19). The juxtaposition of sunset and sunrise establish her dominion as the antithesis of that of the sun god Shamash, whose kingdom extended from sunrise to sunset. It was a dark place and the dead, naked or clothed with wings like birds, wandered with nothing to drink and only dust to eat. Whatever they had achieved in life, the only sentence was death, pronounced by Ereshkigal and recorded by Geshtinanna, Dumuzi's sister who became Ereshkigal's scribe.

In a scene from the *Epic of Gilgamesh*, the hero Enkidu relates a dream in which he visited the Underworld, and describes Ereshkigal as follows: 'No garment covers her shining shoulders, no linen is spread over her shining breast, her finger [nails] she wields like a rake, she wrenches [her hair] out like leeks' (trans. A.R. George). It may have been because of her nakedness that she did not want to be upstaged by Inanna/Ishtar and obliged her to appear naked before her. A text of about 650 BC describes a prince's visit in a dream to the Underworld, which is peopled by hellish winged demons with talons. The Underworld was 'the land of no return' so that even Ereshkigal could not leave her kingdom. The god Nergal almost lost his life when he visited her, but agreed to become her second husband instead. The most famous visitor to the Underworld was Inanna/Ishtar, an account of whose visit was given above.

In 1980 Edith Porada identified the goddess on the Queen of the Night relief as 'the female ruler of the dead or … some other major figure of the Old Babylonian pantheon which was occasionally associated with death'. It does indeed seem possible that the goddess could be Ereshkigal: the dark background, the lowered wings, the owls (who have a long and close association with death) and the scale pattern are all features that are associated with the Underworld. As a goddess, Ereshkigal was entitled to the horned headdress and the rod-and-ring symbol. Her frontality is static and immutable and, as Queen of the Underworld where 'fates were determined', hers was the ultimate judgement: she might well have been entitled to two rod-and-ring symbols. Indeed, as noted by Elisabeth

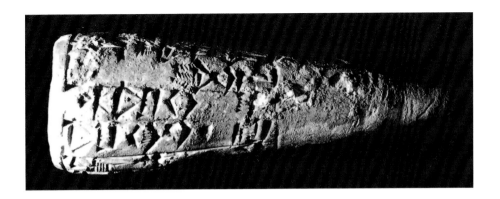

von der Osten-Sacken, Ereshkigal's second rod-and-ring symbol could have been the one removed from her sister Ishtar on her way into the Underworld (see p. 42).

The iconographical parallels are Old Babylonian (some illustrated on figs 5a–b and 6a–f; only fig. 6g is later). Unfortunately, no definite connection with Ereshkigal can be made, as she has no known iconography: her association with death made her an unpopular subject. The texts that were known in the Old Babylonian period do not mention lions in connection with the Underworld and Ereshkigal, but nor do they mention a lion and weapons as attributes of Inanna/Ishtar, for whom an iconography had already been long-established. This lack of relationship between text and picture is a perennial problem where Mesopotamia is concerned.

There is no solution, therefore, except to wait until we find a very detailed description that perfectly matches our goddess, or discover an object of this type bearing the inscription: 'This is a true likeness of ...' – both very unlikely eventualities. In the meantime, the goddess on the Queen of the Night relief will have to join the long procession of unidentified Mesopotamian deities.

Further reading

Albenda, P., 'The "Queen of the Night" plaque – a revisit', *Journal of the American Oriental Society* 125/2 (2005), pp. 171–90.

Black, J. and Green, A., *Gods, Demons and Symbols of Ancient Mesopotamia* (London, 1992; 2nd edn, 1998).

Collon, D., 'The Queen under attack – a rejoinder', *Iraq* 69 (2007), in press.

Curtis, J.E. and Collon, D., 'Ladies of easy virtue' in H. Gasche and B. Hrouda (eds), *Collectanea Orientalia – Histoire, arts de l'espace et industrie de la terre: Etudes offertes à Agnès Spycket* (Neuchâtel and Paris, 1996), pp. 89–95.

Frankfort, H., 'The Burney Relief', *Archiv für Orientforschung* 12 (1937–9), pp. 128–35.

Jacobsen, T., 'Pictures and pictorial language (The Burney Relief)' in M. Mindlin, M.J. Geller and J.E. Wansborough (eds), *Figurative Language in the Ancient Near East* (London, 1987), pp. 1–11.

Jardine, W., *Mammalia* vol. II, *Felidae* (The Naturalist's Library, London, 1834), esp. pp. 120–23 and pl. 1.

Porada, E., 'The iconography of death in Mesopotamia' in B. Alster (ed.), *Death in Mesopotamia. XXVIe Rencontre Assyriologique Internationale* (Mesopotamia 8, 1980), pp. 259–70.

Van De Mieroop, M., *Hammurabi of Babylon – A Biography* (Oxford, 2005).

von der Osten-Sacken, E., 'Überlegungen zur Göttin auf dem Burneyrelief' in S. Parpola and R. Whiting (eds), *Sex and Gender in the Ancient Near East: Proceedings of the 47th Rencontre Assyriologique Internationale, Helsinki, July 2–6, 2001* (Helsinki, 2002), pp. 479–87.

Photographic credits